THIS COLORING BOOK BELONGS TO:

.................................

DATE:

.................................

Some graphic elements in this book have been created by Starline, Macrovector, Winkimages - Freepik.com

No portion of this publication may be reproduced or transmitted in any form or by any means, electronic or mechanical, including, but not limited to, audio recordings, facsimiles, photocopying, or information storage and retrieval systems without explicit written permission from the author or publisher.

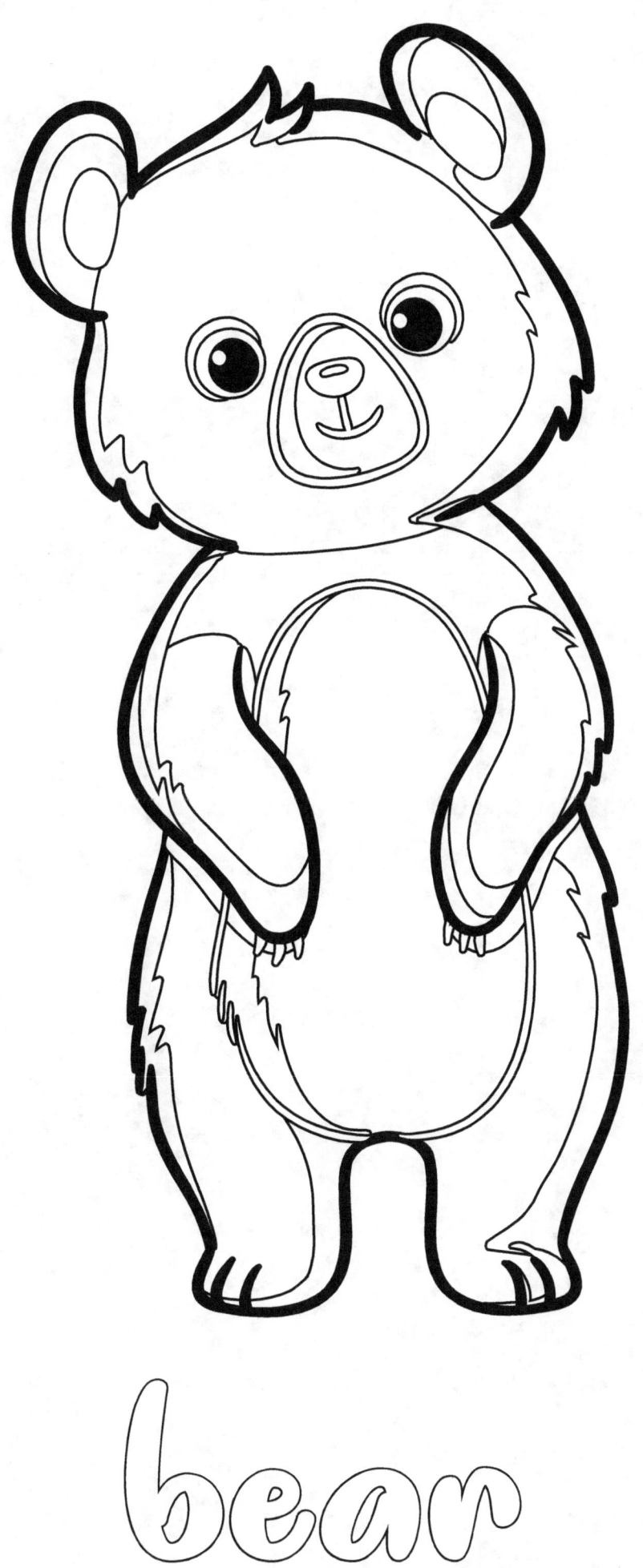

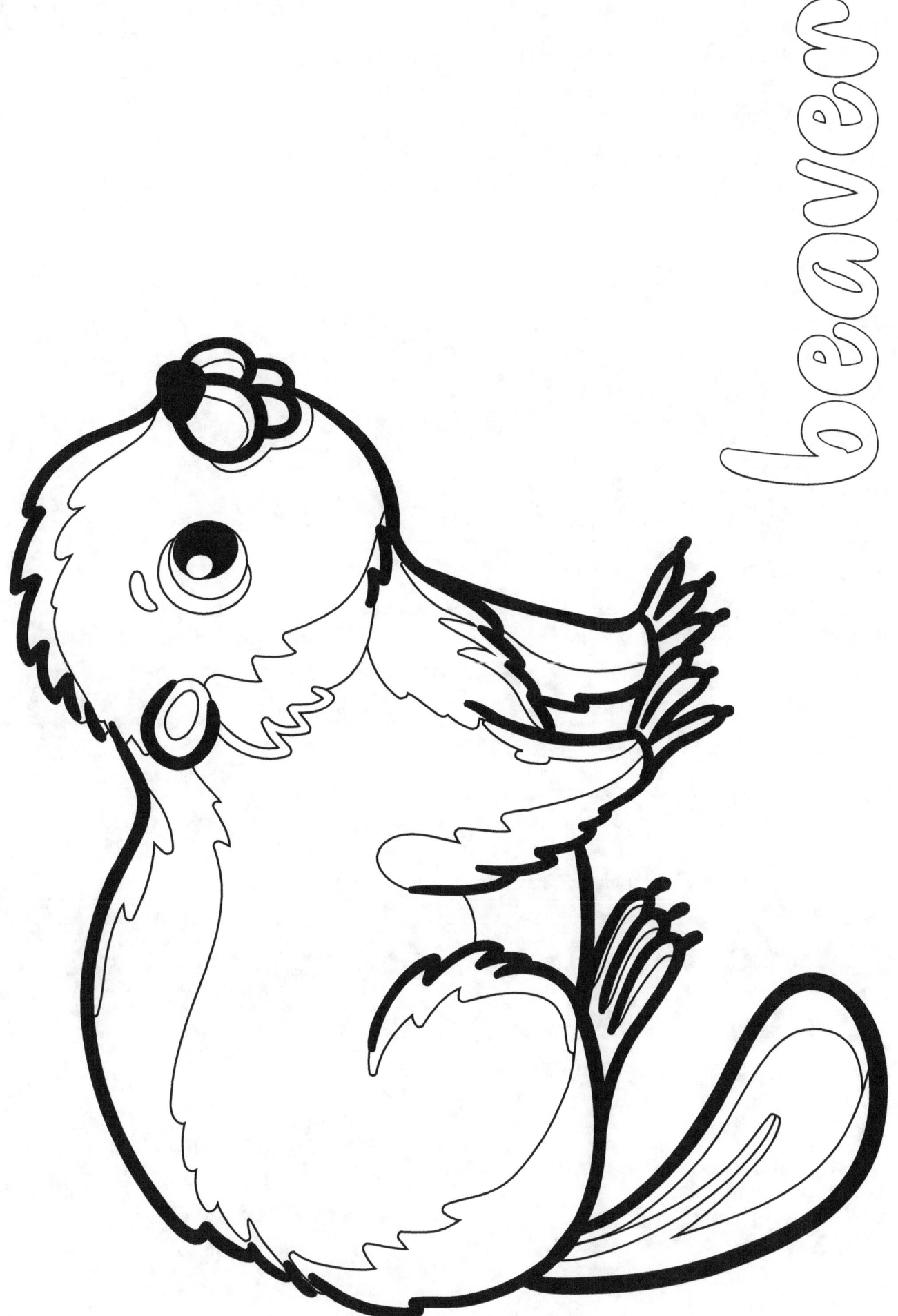

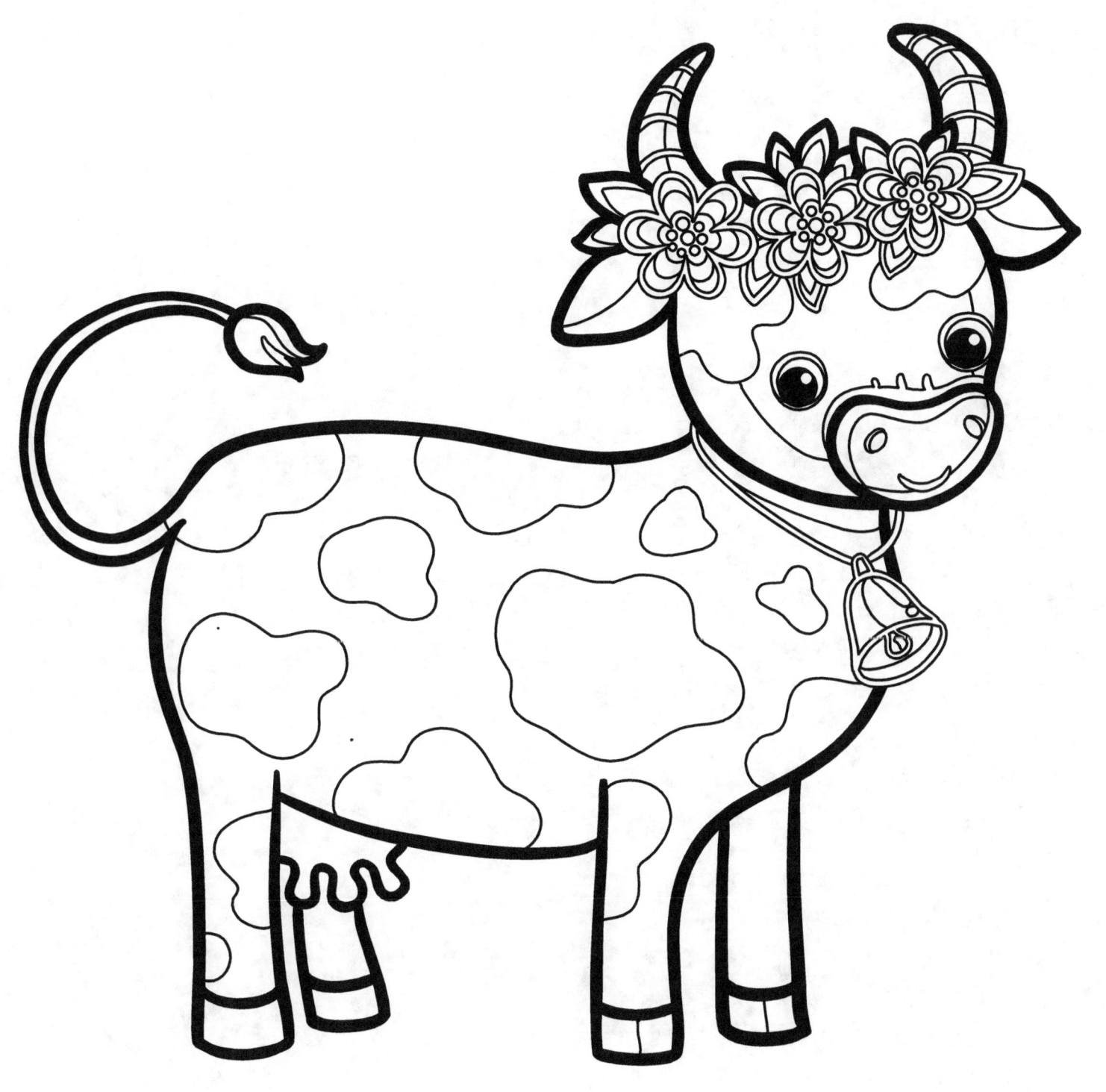

COW

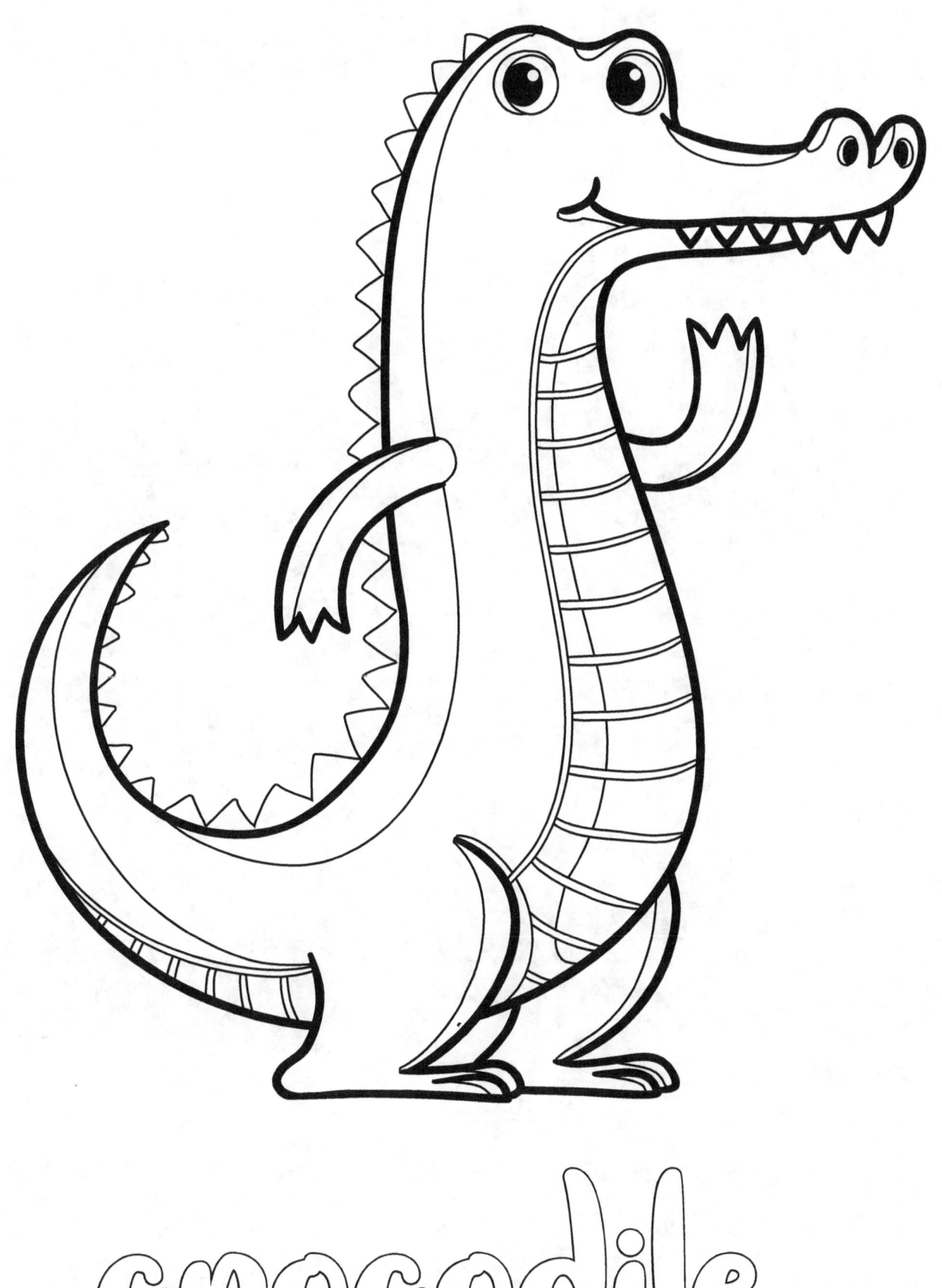

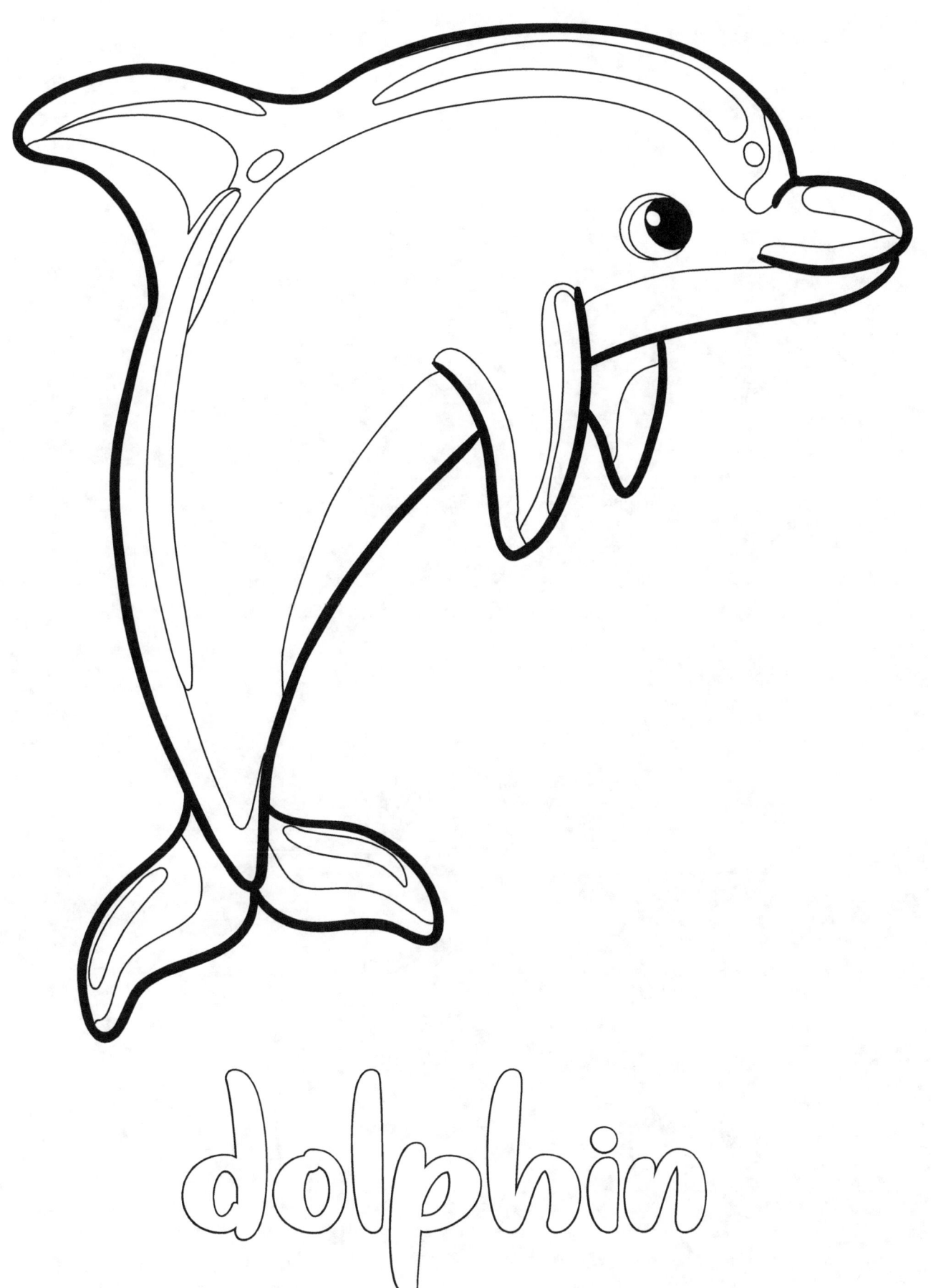

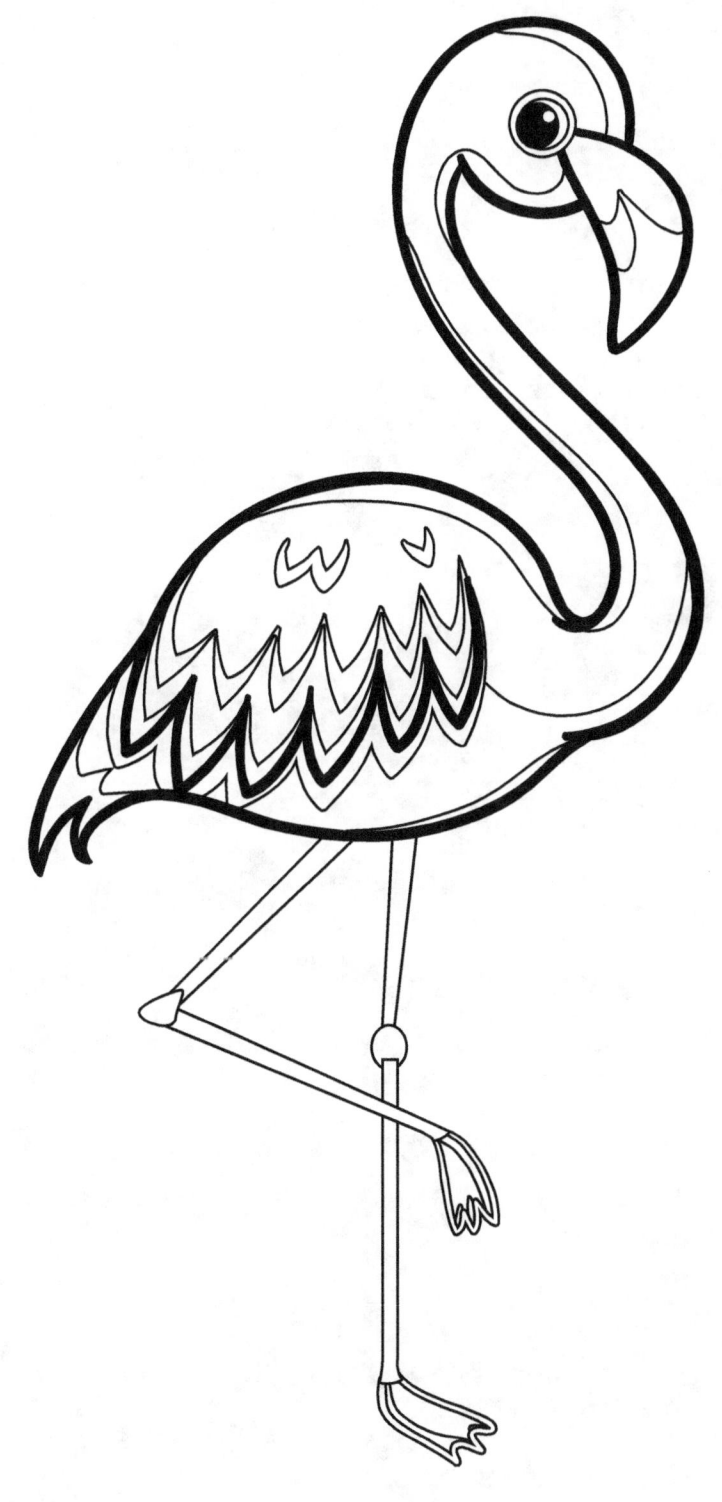

flamingo

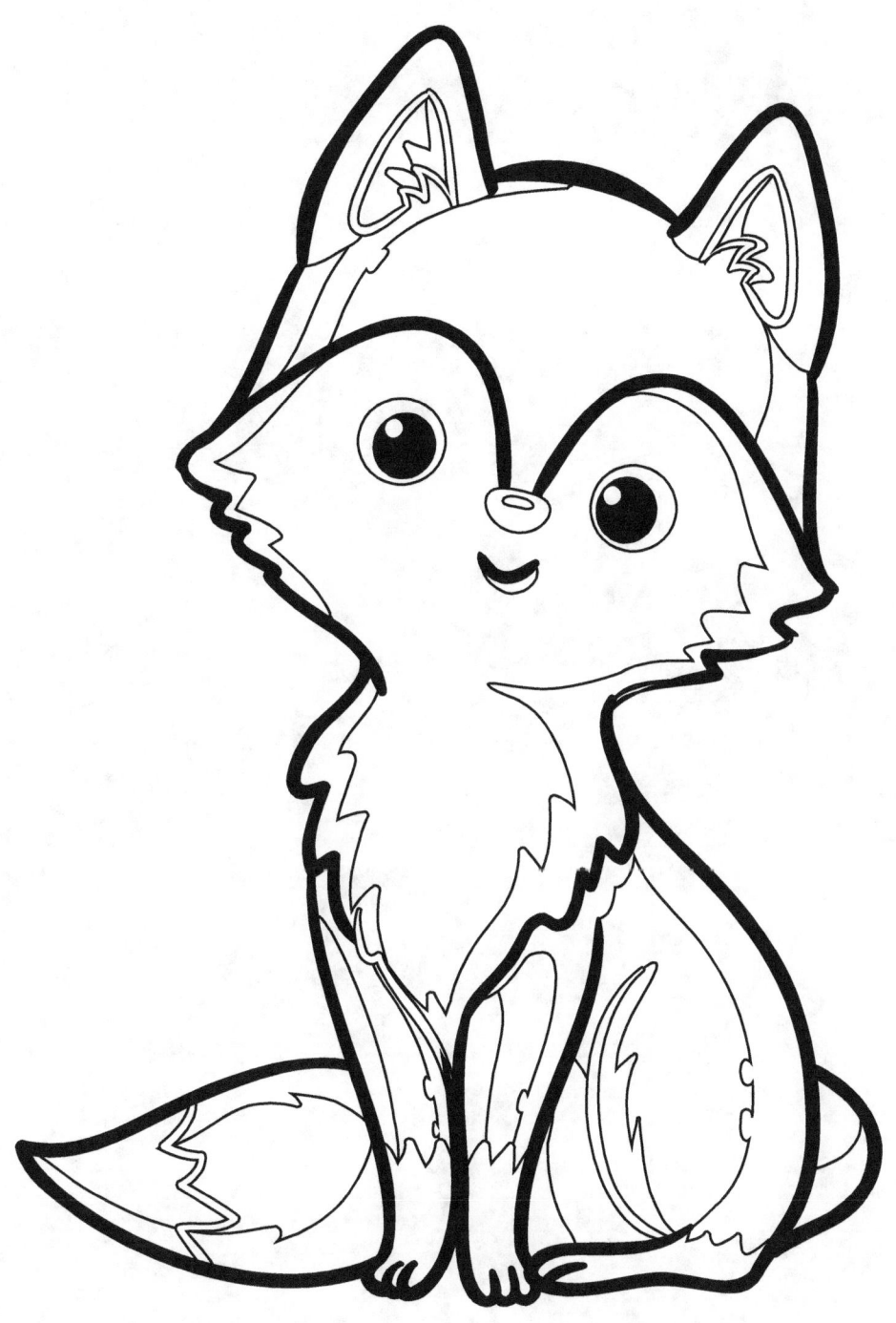

fox

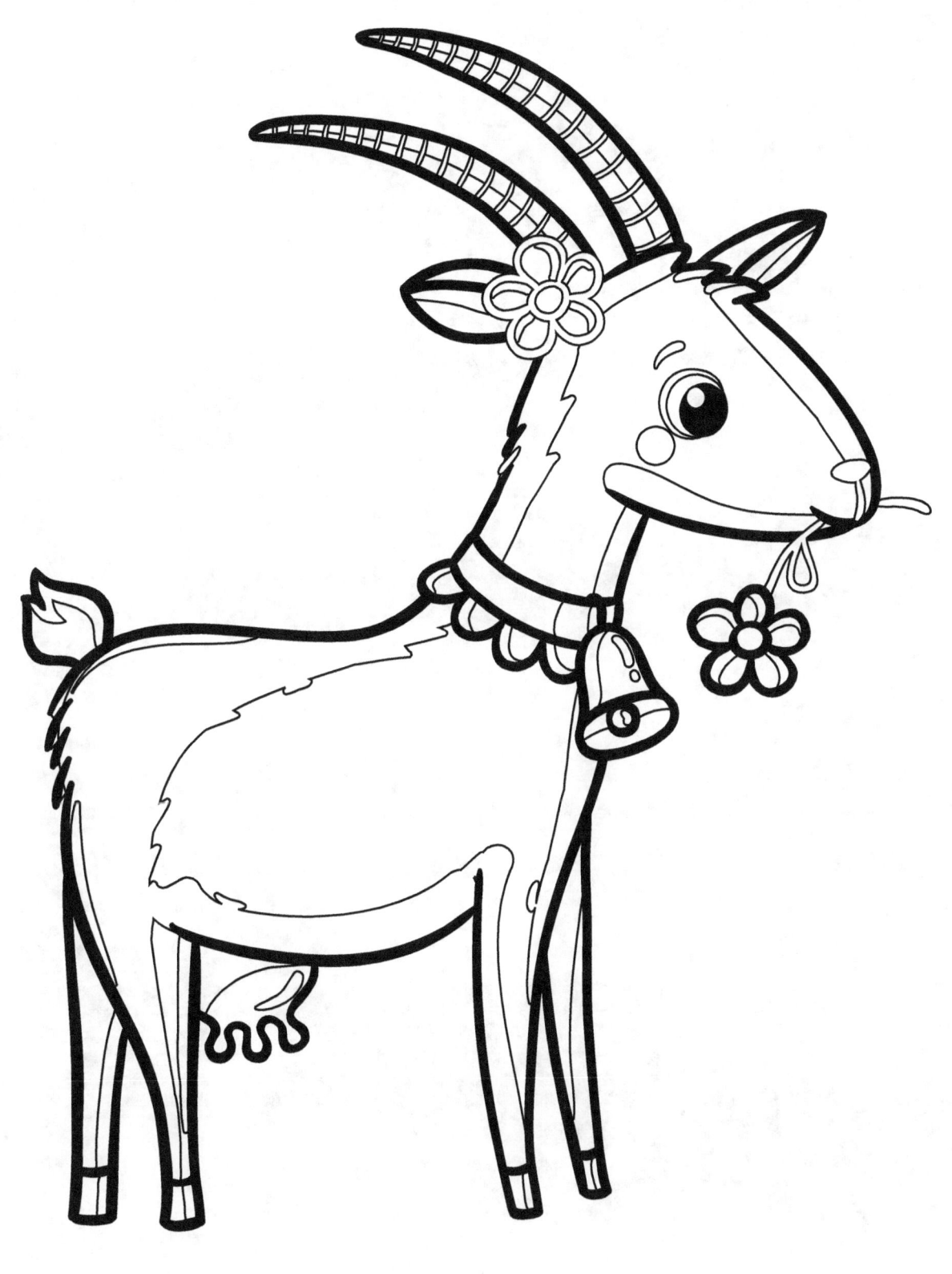

goat

hedgehog

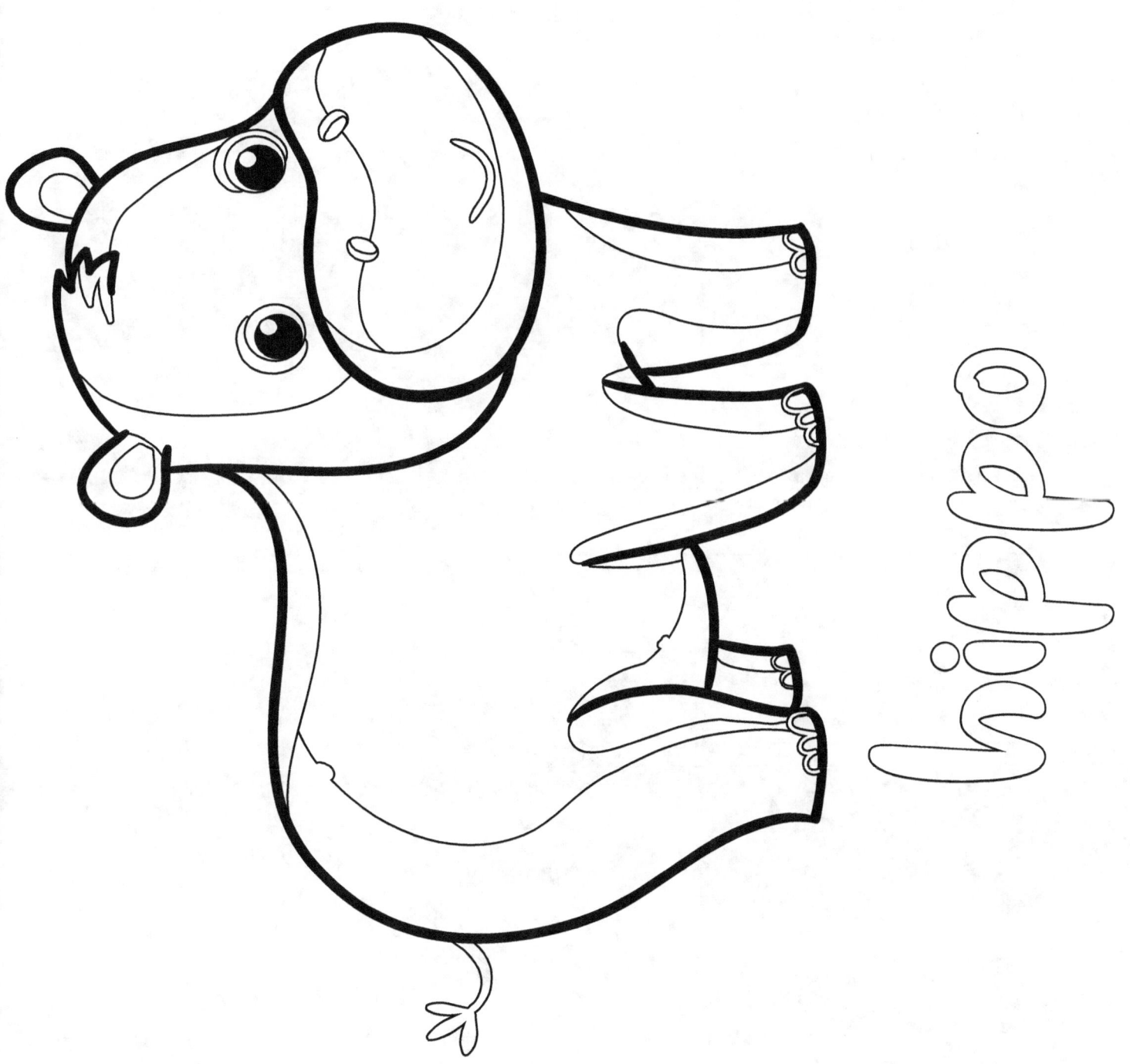

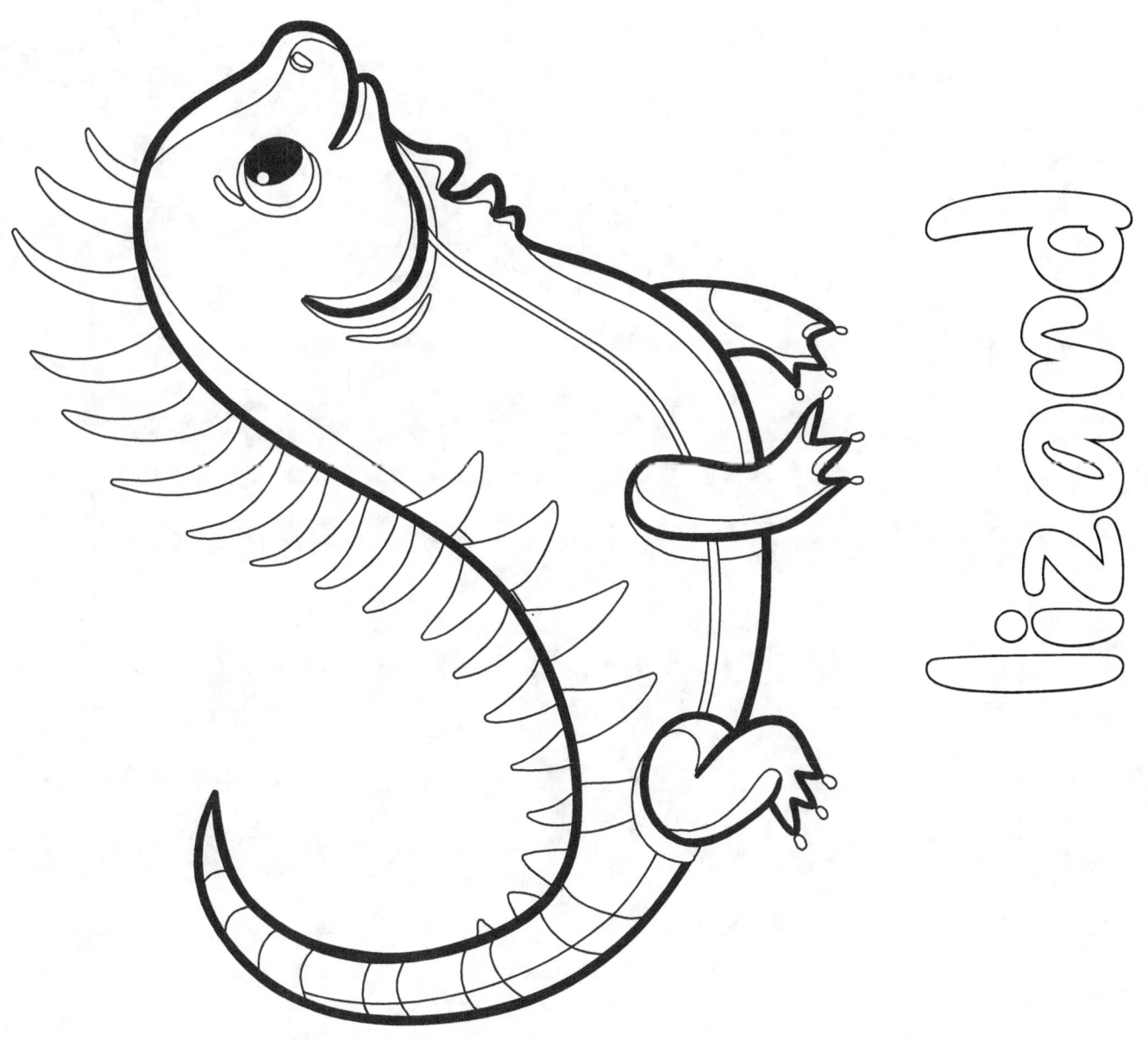
lizard

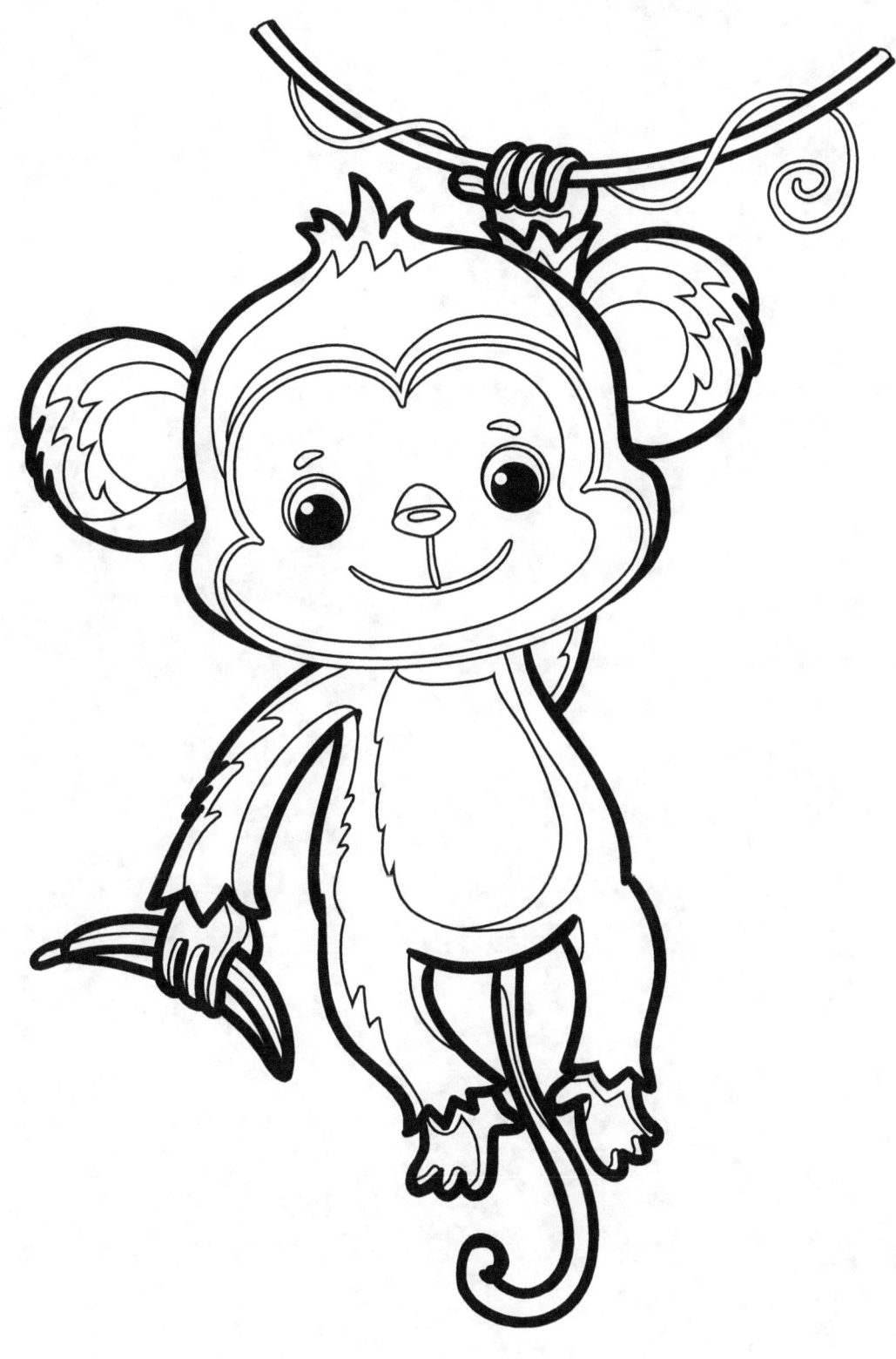

monkey

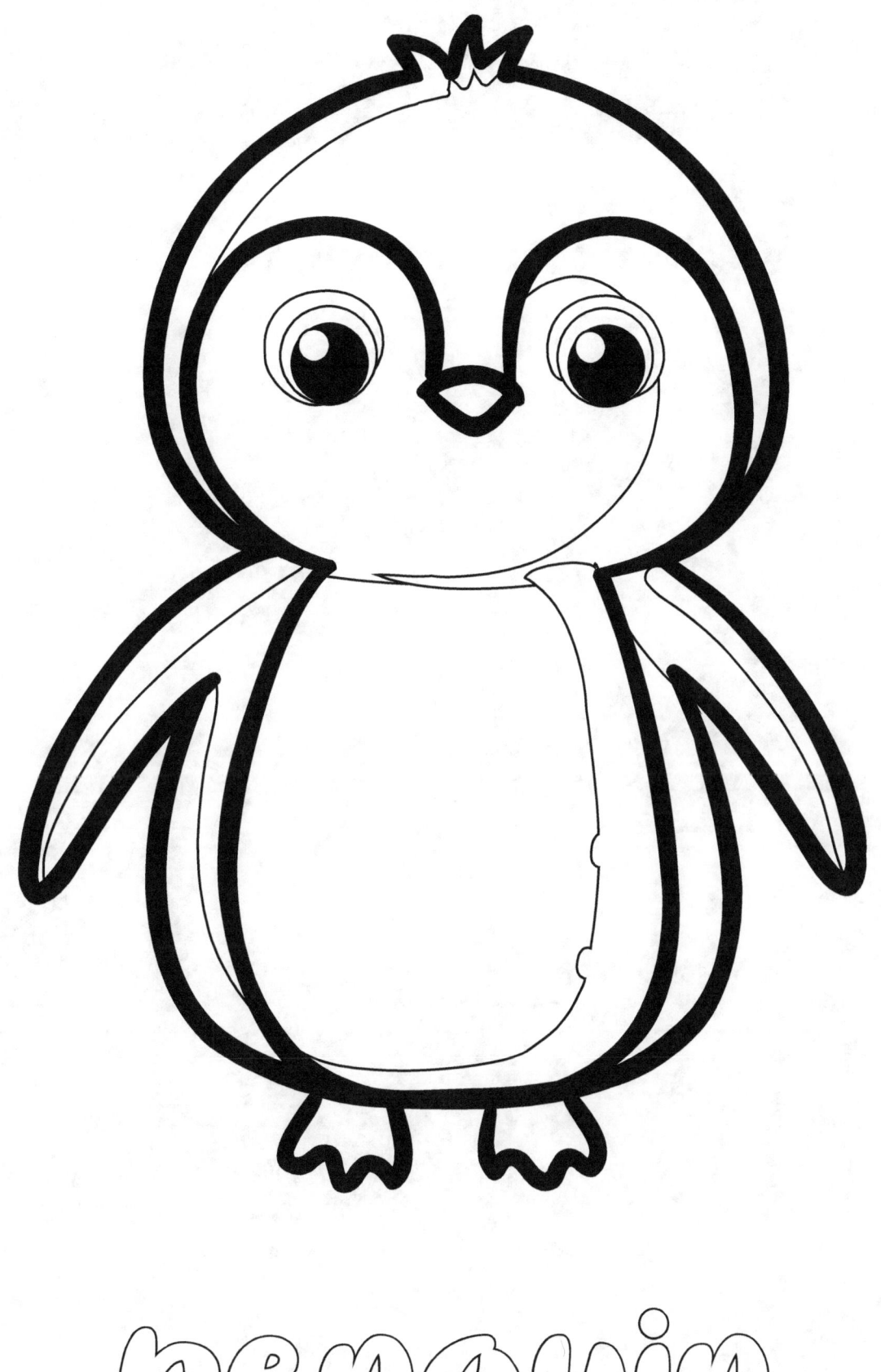

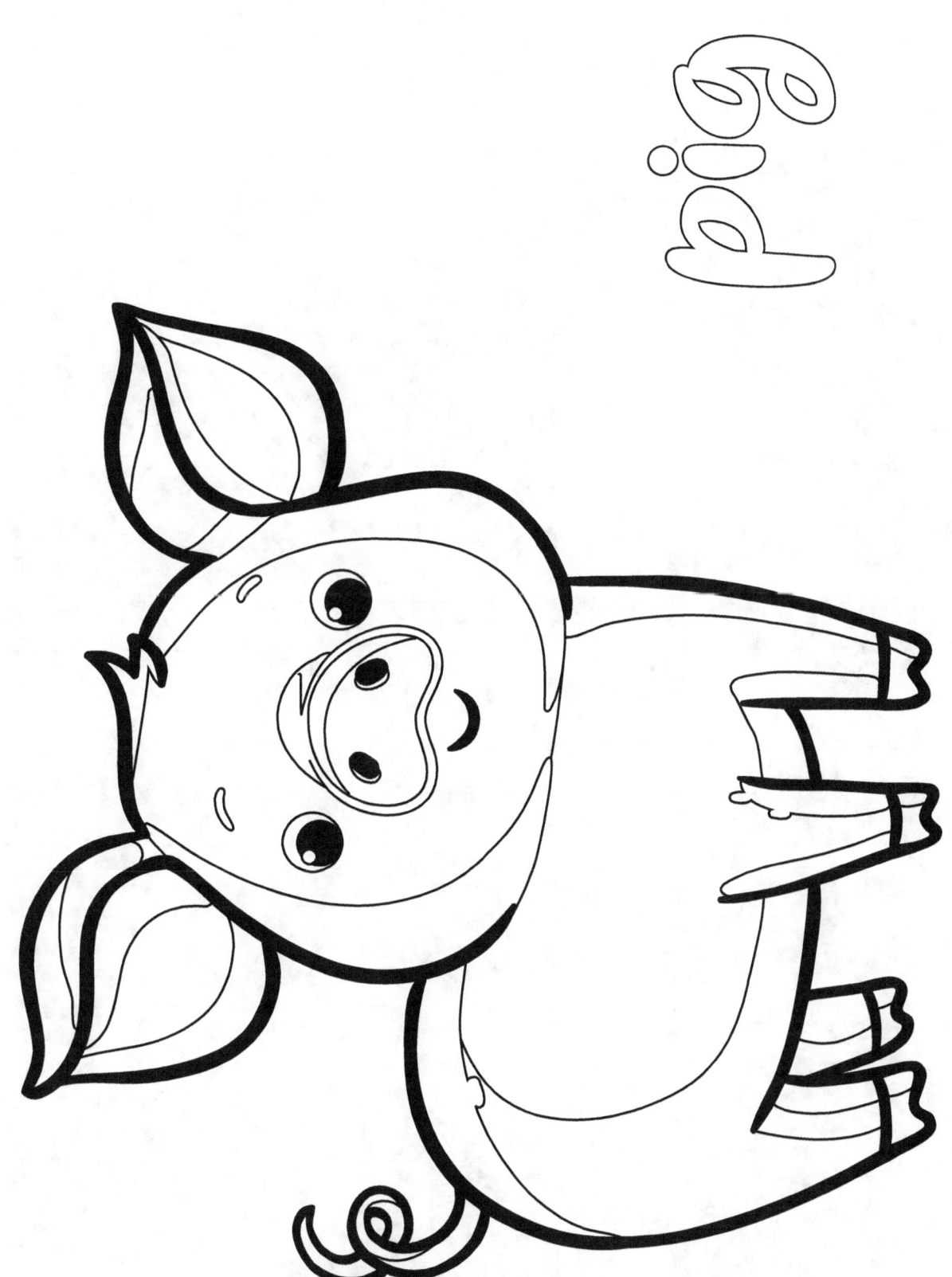

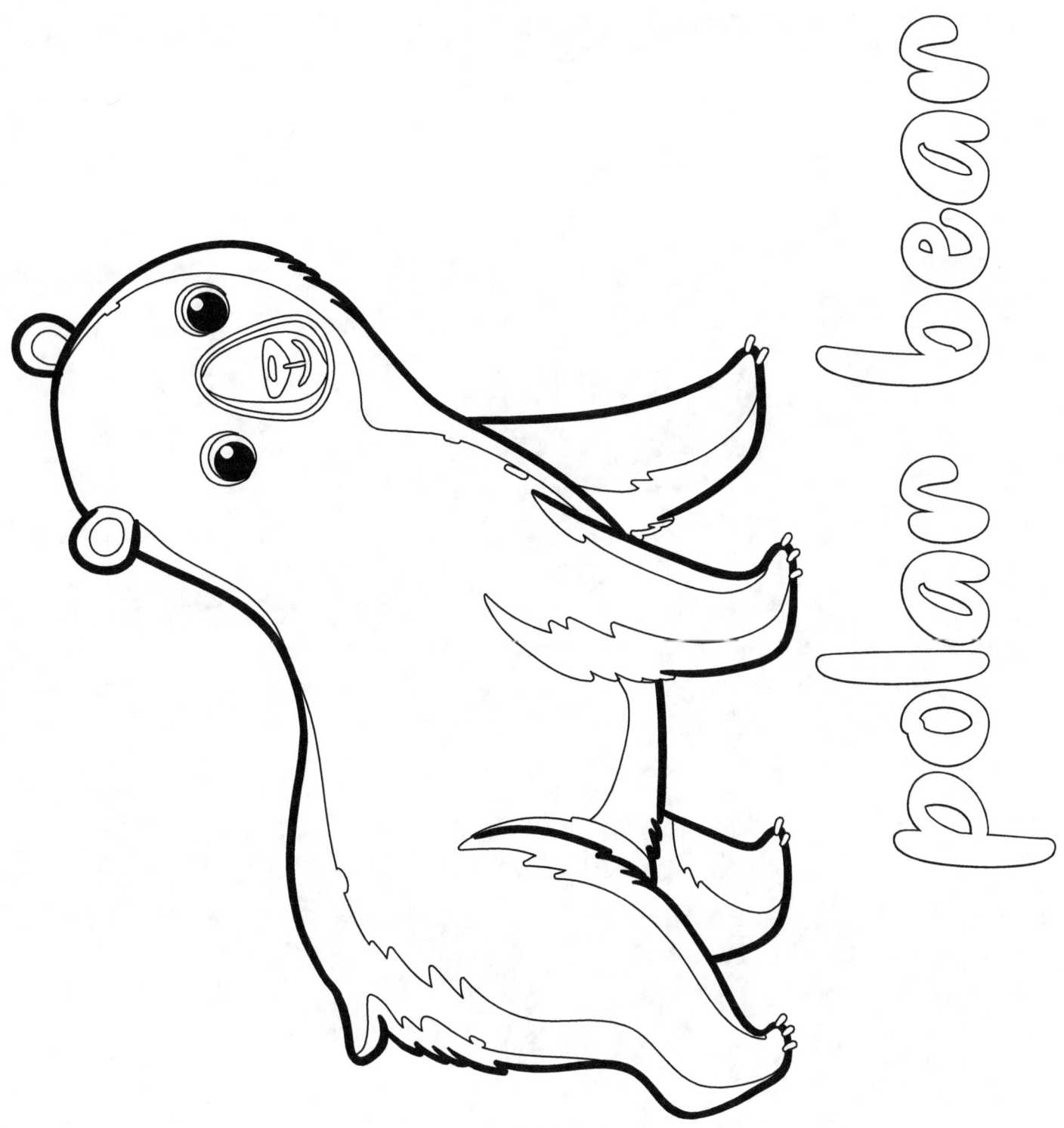

polar bear

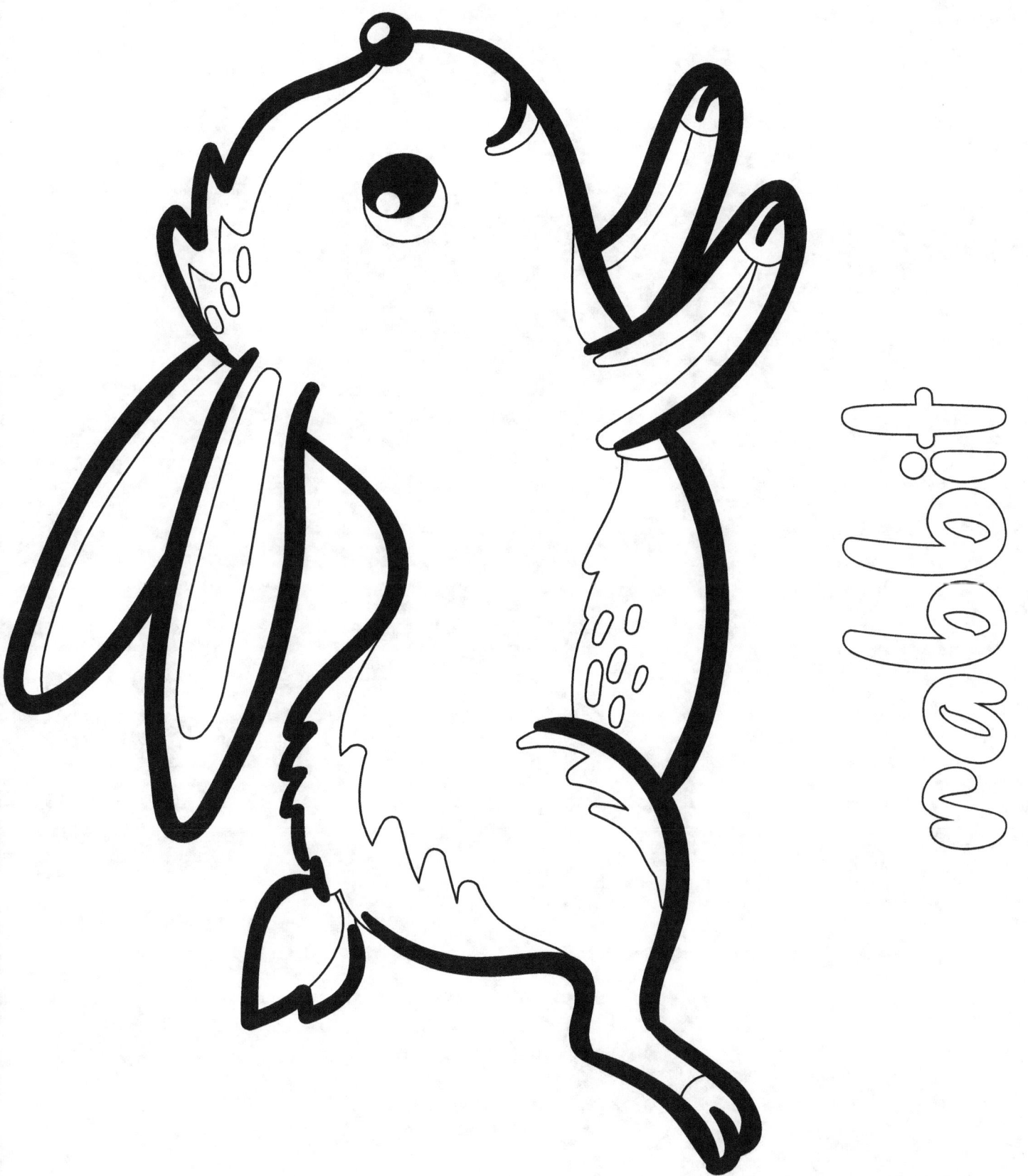

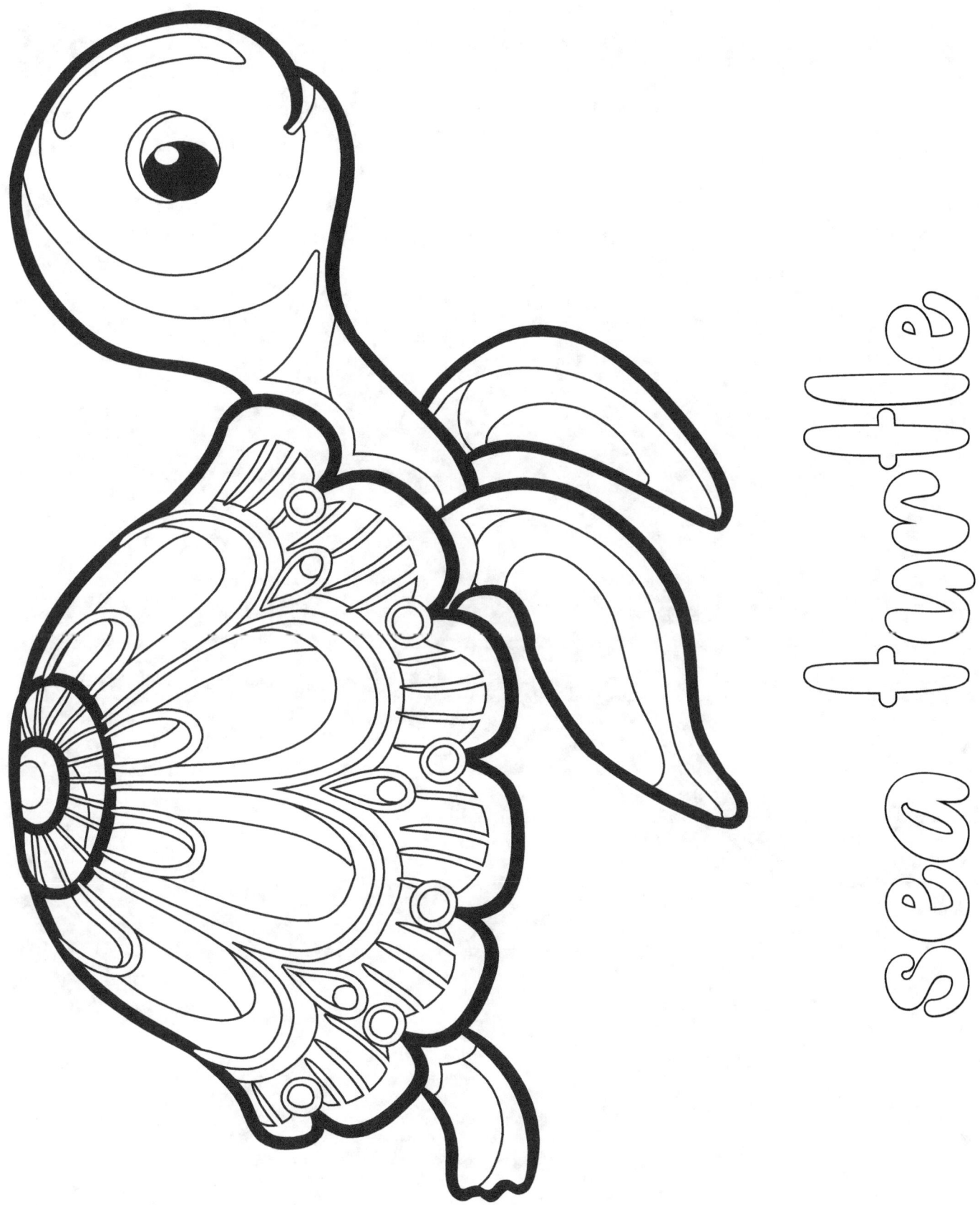

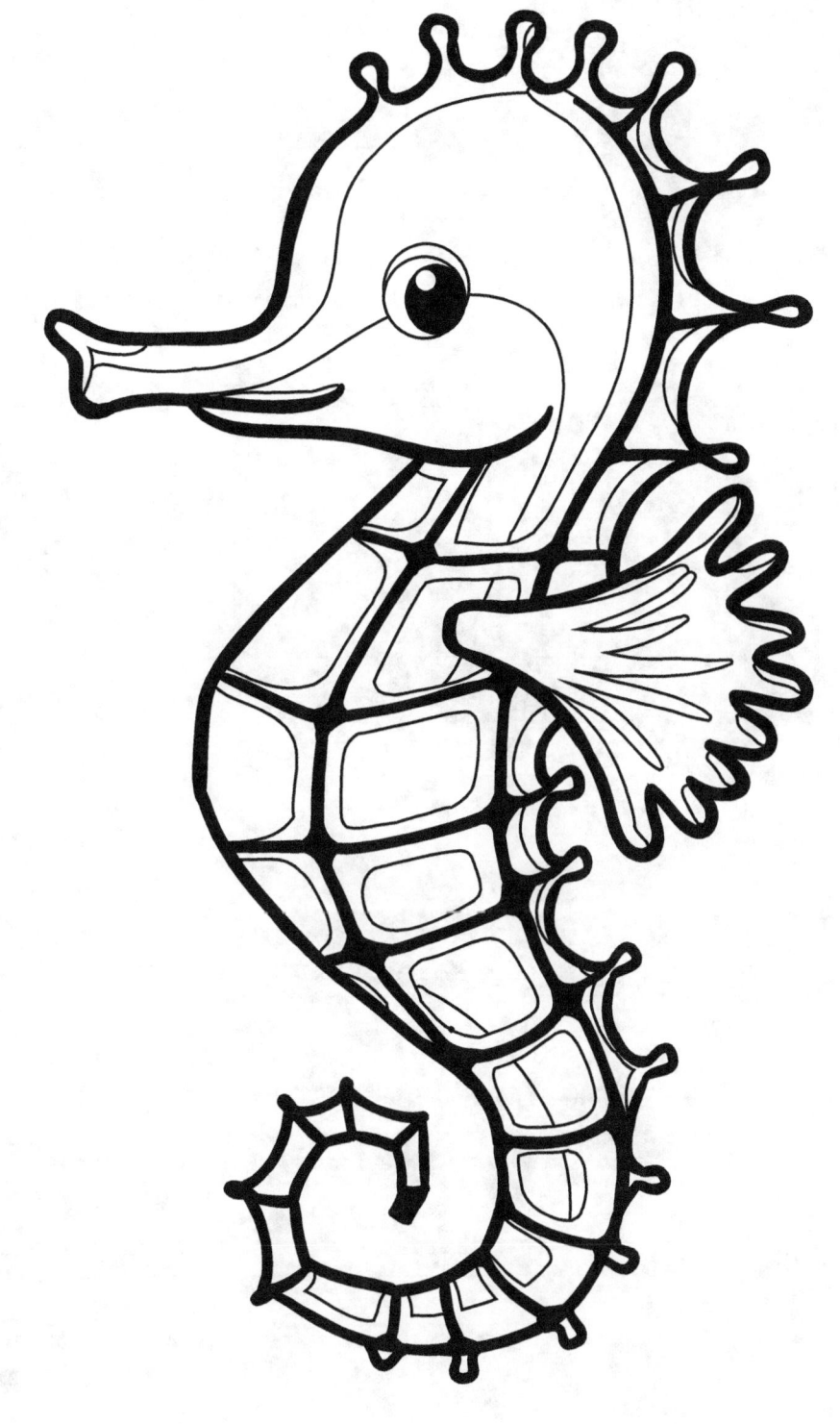

seahorse

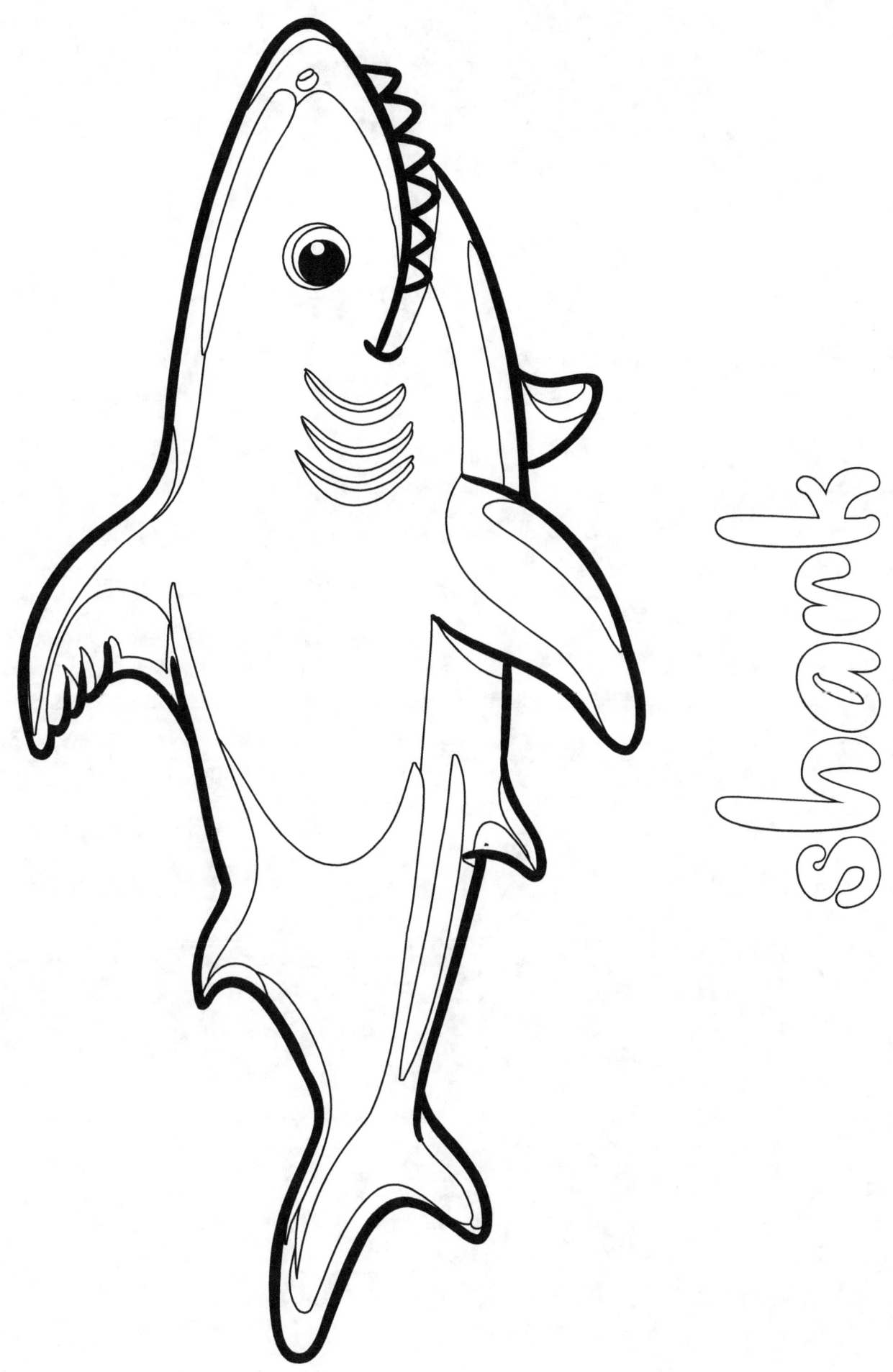

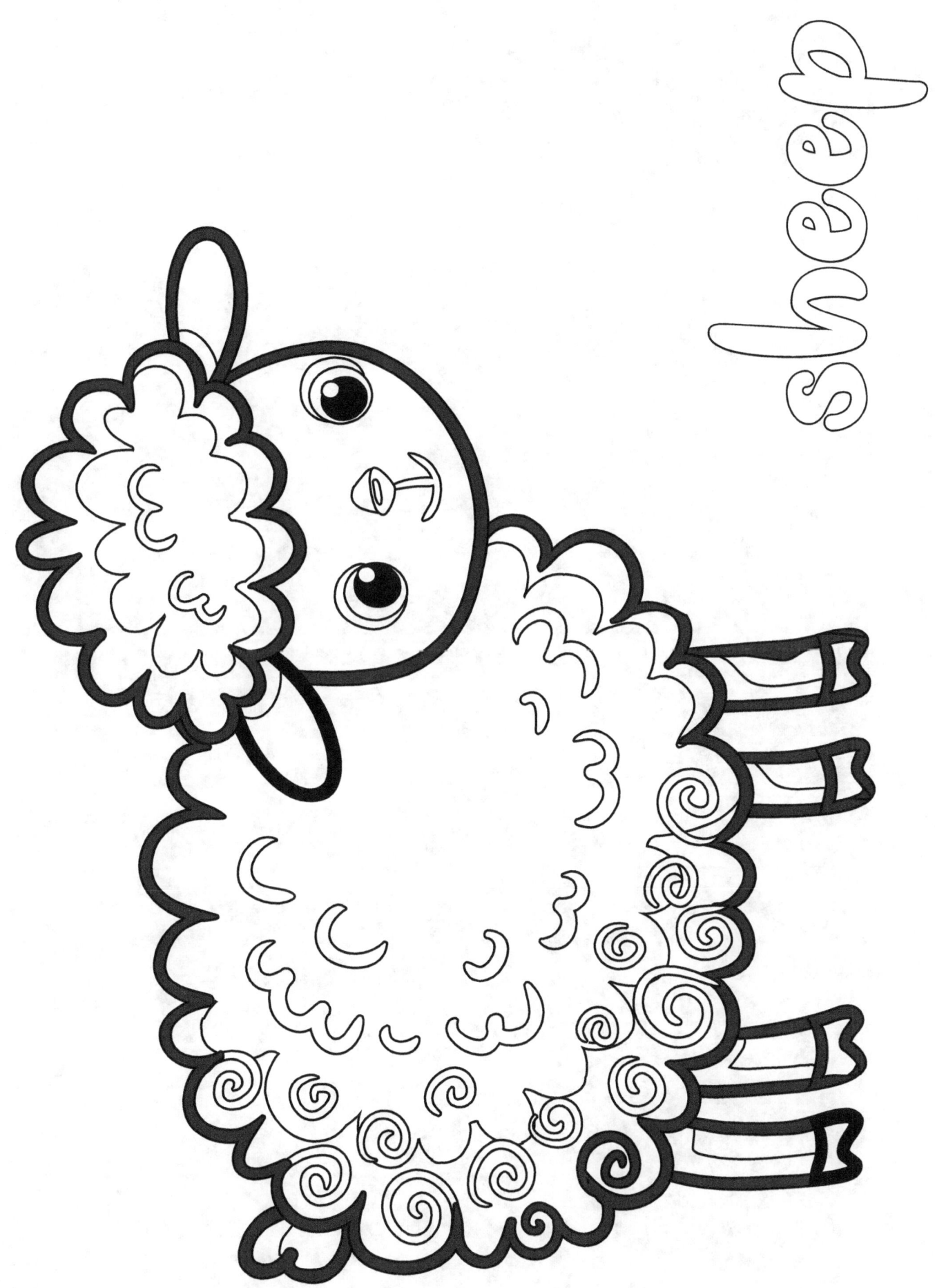

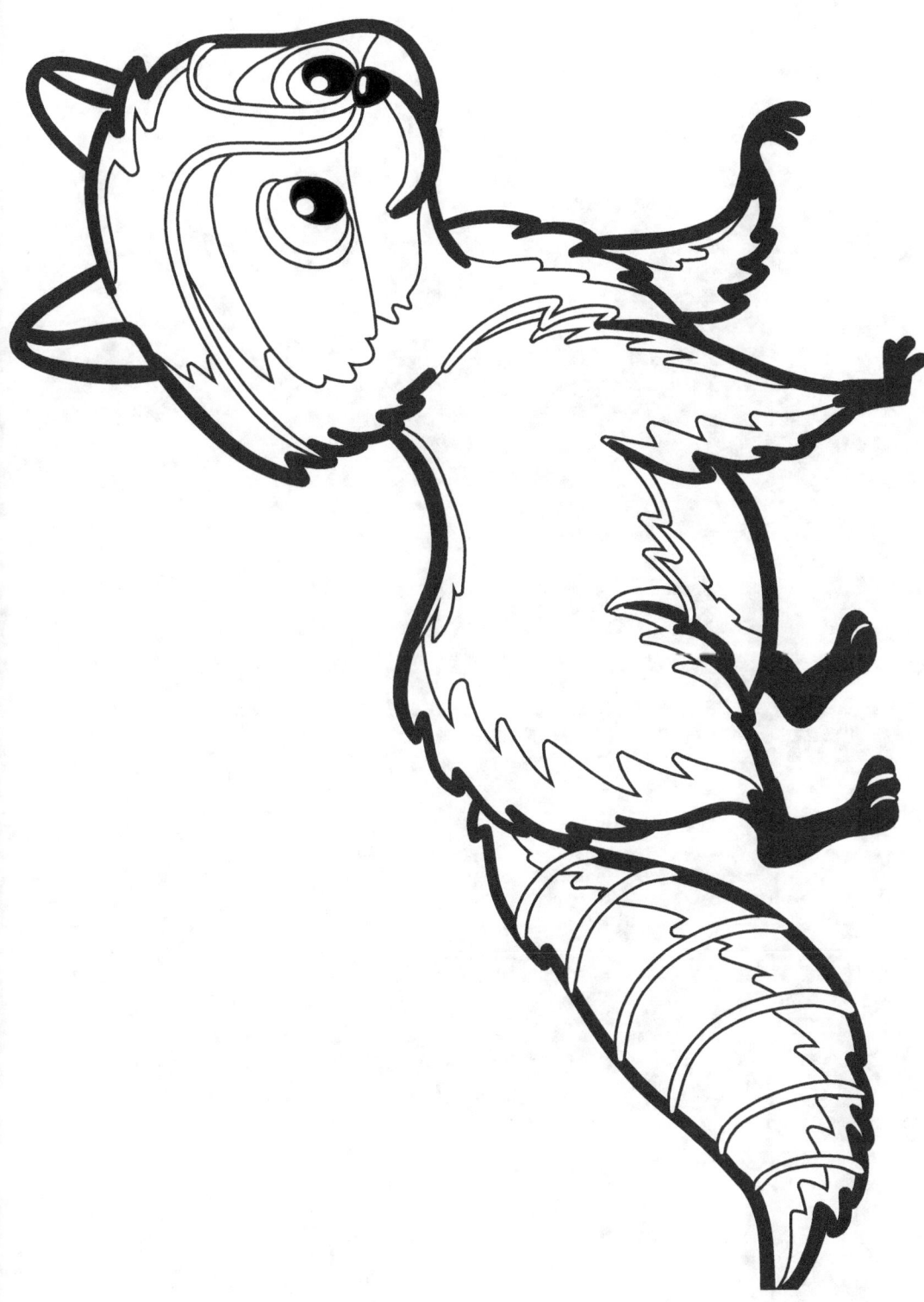

skunk

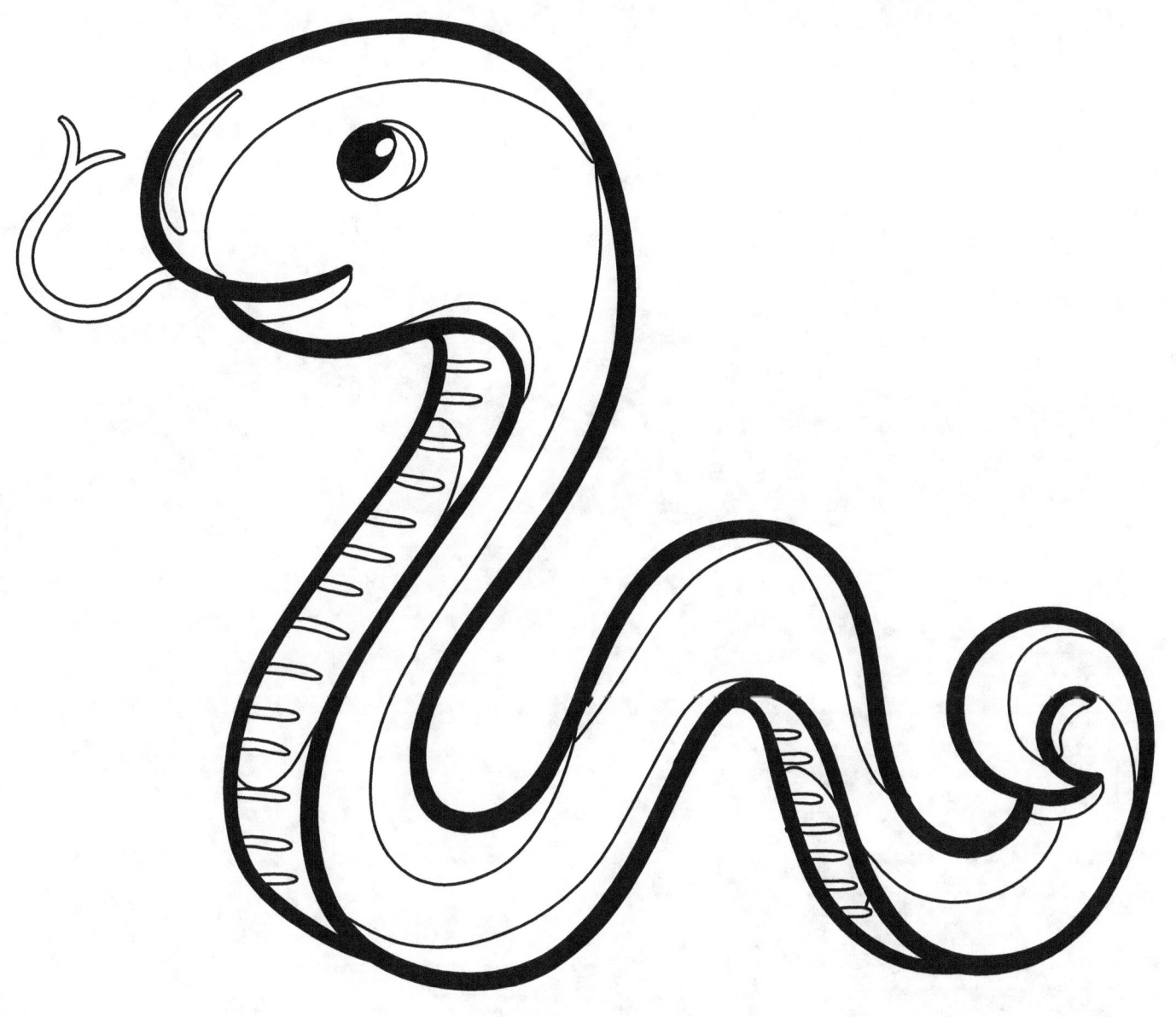

snake

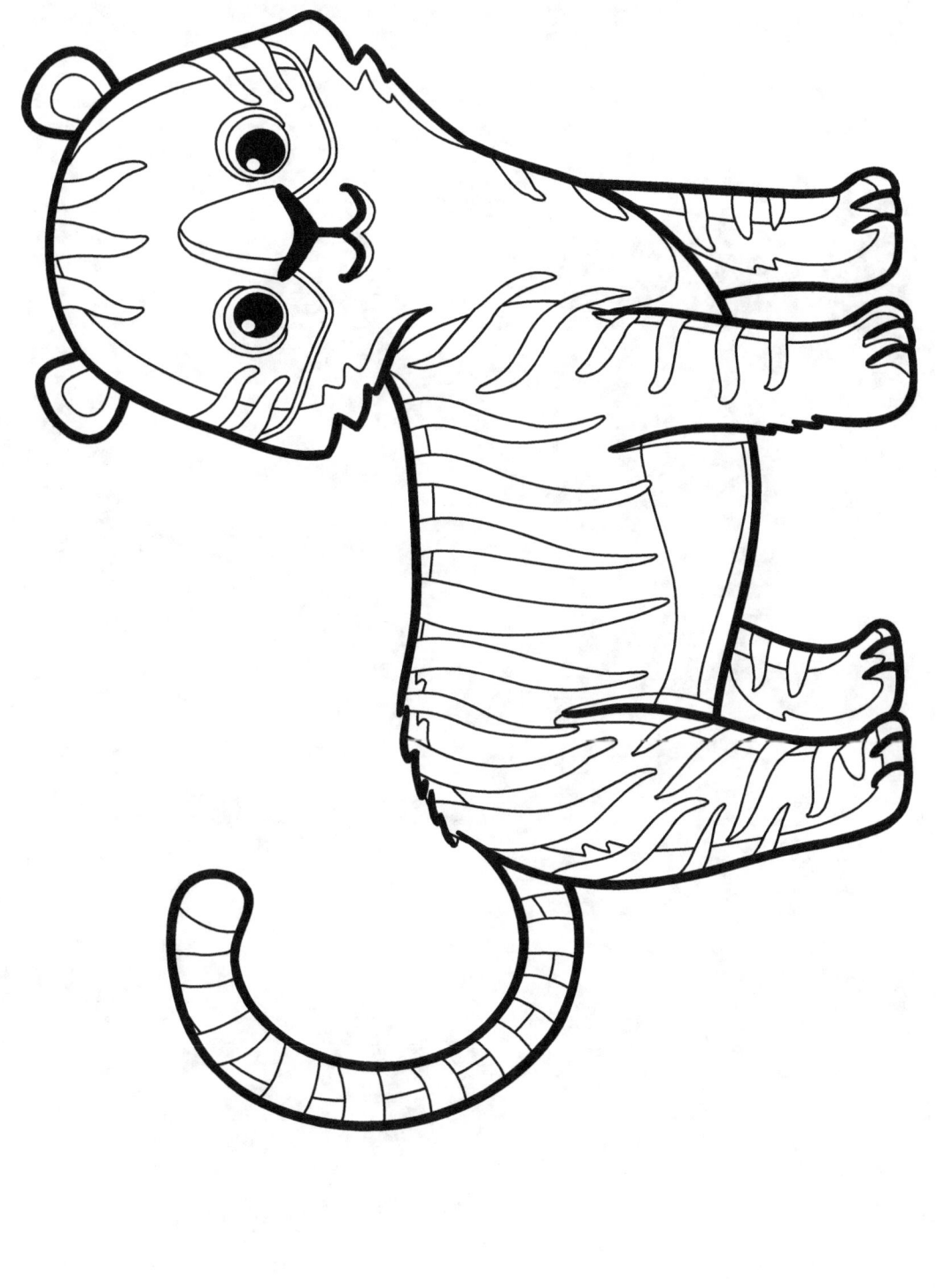

tiger

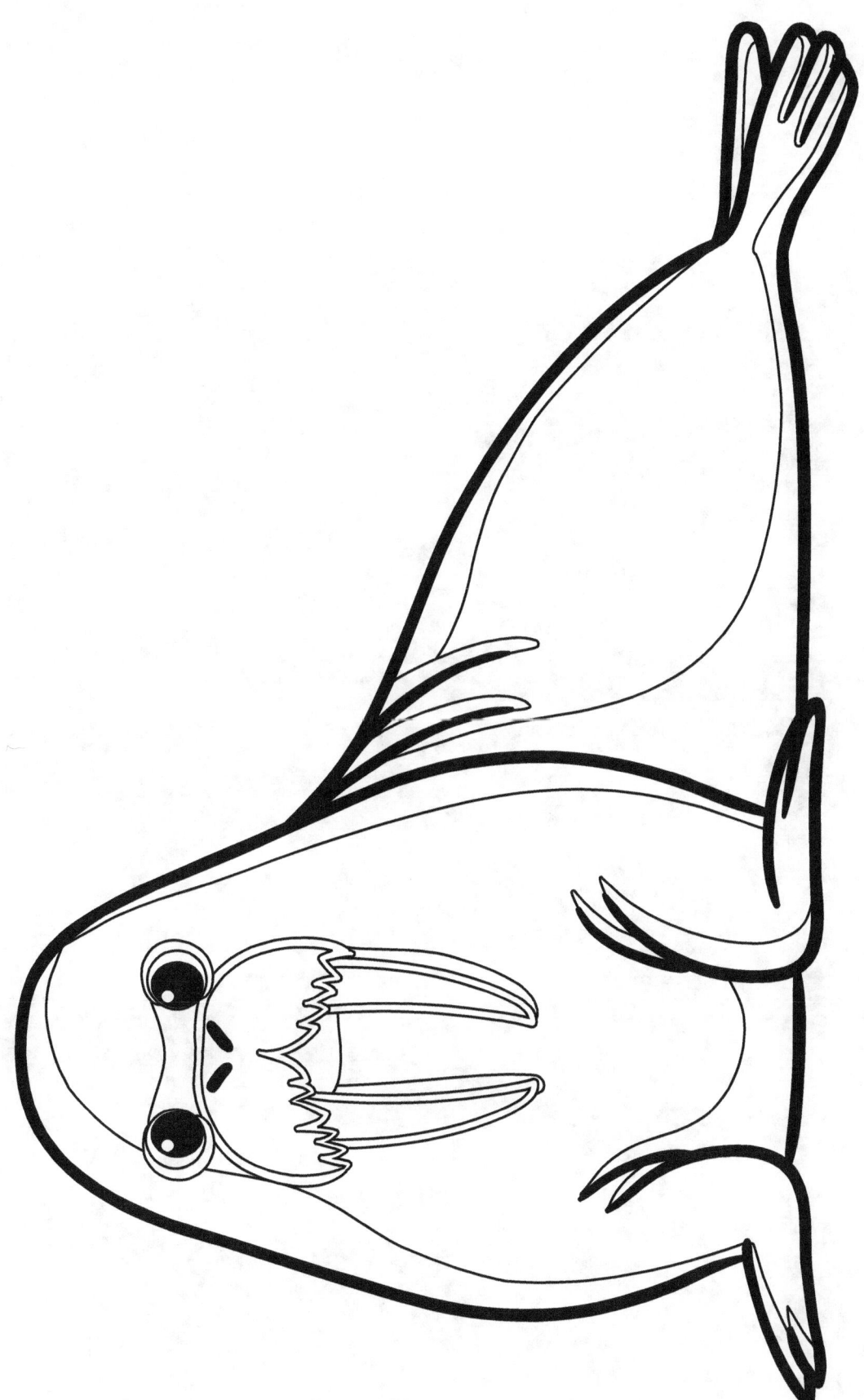
walrus

I love animals because ...

I love animals because ...

www.ingramcontent.com/pod-product-compliance
Lightning Source LLC
Chambersburg PA
CBHW080907220526
45466CB00011BA/3493